David Wrzga

Understanding Artistic Artwork

Diana Wyzga

Understanding Autistic Artwork

LAP LAMBERT Academic Publishing

Impressum / Imprint

Bibliografische Information der Deutschen Nationalbibliothek: Die Deutsche Nationalbibliothek verzeichnet diese Publikation in der Deutschen Nationalbibliografie; detaillierte bibliografische Daten sind im Internet über http://dnb.d-nb.de abrufbar.
Alle in diesem Buch genannten Marken und Produktnamen unterliegen warenzeichen-, marken- oder patentrechtlichem Schutz bzw. sind Warenzeichen oder eingetragene Warenzeichen der jeweiligen Inhaber. Die Wiedergabe von Marken, Produktnamen, Gebrauchsnamen, Handelsnamen, Warenbezeichnungen u.s.w. in diesem Werk berechtigt auch ohne besondere Kennzeichnung nicht zu der Annahme, dass solche Namen im Sinne der Warenzeichen- und Markenschutzgesetzgebung als frei zu betrachten wären und daher von jedermann benutzt werden dürften.

Bibliographic information published by the Deutsche Nationalbibliothek: The Deutsche Nationalbibliothek lists this publication in the Deutsche Nationalbibliografie; detailed bibliographic data are available in the Internet at http://dnb.d-nb.de.
Any brand names and product names mentioned in this book are subject to trademark, brand or patent protection and are trademarks or registered trademarks of their respective holders. The use of brand names, product names, common names, trade names, product descriptions etc. even without a particular marking in this works is in no way to be construed to mean that such names may be regarded as unrestricted in respect of trademark and brand protection legislation and could thus be used by anyone.

Coverbild / Cover image: www.ingimage.com

Verlag / Publisher:
LAP LAMBERT Academic Publishing
ist ein Imprint der / is a trademark of
OmniScriptum GmbH & Co. KG
Heinrich-Böcking-Str. 6-8, 66121 Saarbrücken, Deutschland / Germany
Email: info@lap-publishing.com

Herstellung: siehe letzte Seite /
Printed at: see last page
ISBN: 978-3-659-46914-5

BOSTON UNIVERSITY

COLLEGE OF FINE ARTS

Final research project

Understanding Autistic Artwork

by

DIANA WYZGA

BFA Art Education, Boston University, 2008

Submitted in partial fulfillment of the

Requirements for the degree of

MA in Art Education

Abstract

Inspired by personal work with autistic children and the pursuit for more knowledge, the research in this study contributes significant findings to the field of art and autism. In this thesis, the artworks and processes of autistic and typically developing students were compared and analyzed. Using a unit and lesson inspired by the bold shapes and colors found in the selected paintings of Austrian artist Friedensreich Hundertwasser, the study analyzes the artwork produced by both typically developing and autistic students in kindergarten, first, and fourth grade. Throughout the study, research not only analyzes these similarities and differences, but also places a strong emphasis on answering *why* certain results occurred. This comprehensive approach does not isolate the findings of each grade level, but goes on to examine patterns and themes that emerge across the grade levels. In the following chapters, the researcher's methods and motivation are detailed. The results are carefully analyzed and important conclusions that affect educators in every field are explained.

Keywords: art, autism, comparison, Hundertwasser

Table of Contents

Chapter 1: Introduction

Background to the Study

As rates of individuals with autism spectrum disorder rise (Begley, 2012), educators must find new ways to ensure that such individuals do not to go through life quieted by their disorder. Through visual art, individuals with autism discover a wonderful means of communication and self-expression. Though art shows extraordinary promise as a means of expression, it is essential that educators understand autistic children's artistic process and artwork. This study proposed an investigation to obtain a more comprehensive understanding of this artistic process. From a comparative perspective, the study explored the similarities and differences in the art making process and art of autistic children compared to that of typically developing children.

The proposed research does not attempt to suggest that the characteristics of a particular disability are fixed, or to what extent they are changeable. Instead, the study aimed to gain more insight into any overarching themes or consistencies that can be transposed into beneficial information. It is the responsibility of the teachers, aides, parents and mentors of autistic individuals to assist them with knowledge and guidance. Temple Grandin recalls in *Thinking in Pictures* (1995), "Throughout my life, I have always been helped by understanding teachers and mentors. People with autism desperately need guides to instruct and educated them" (p. 19). Acknowledging the importance of this study is pertinent to its prosperity. As it pertains to autistic individuals, visual art is a perhaps invaluable source of expression and a necessary topic of study. Literary investigations on this topic were reviewed to supplement the data obtained in the proposed study. This literature included the input of art therapists, parents, teachers, and researchers.

Art is primitive. Inherent in humans, the desire to create and make something new is a natural response to our worlds. Teachers must cultivate the artistic urge inside all of their students, regardless of the student's ability or disability. To inspire these young artists to reach their highest potential, one must better understand their process, limitations, and talents. The study, motivated largely by personal experience, investigated the topic of art with autistic children and benefits teachers of every subject.

The main objective of this study was to identify and better understand any similarities and/or differences between the process and artworks of typically developing and autistic children attending West Roxbury Public School. Research focused on examining relationships, patterns, predictable outcomes, and most importantly, what caused the data.

Research Goals

The study provides deep insight into the artwork of autistic students. Previous research and theories support the study's findings. Using typical developmental benchmarks as a point of reference, the study examined the process of autistic artists and analyzed the rationale for the results. This data provides educators with a better understanding towards creating an ideal environment for autistic children to flourish in art.

Research Questions

The research investigated the question: What, if any, are the similarities and/or differences between the process and artworks of typically developing and autistic children attending West Roxbury Public School? This research lent itself to subsequent questions. Most important of these were to discover causes of data. The study therefore pondered whether there were particular aspects of an art lesson that played a more significant role in helping a child reach their highest potential. Research also explored any emerging patterns in the data to find if

the two groups (autistic and typically developing children) converged or diverged in artistic proficiency at a particular age. To answer these questions, data was collected from select students attending West Roxbury Public School after a case study was performed.

Conceptual Framework

To obtain data, the researcher presented an art lesson to two groups of similarly aged students. The analyzed groups each consisted of four to six autistic and typically developing children. After delivering the lesson, the researcher recorded the artistic process and resulting artworks of the students in each group. Following the lesson, the data was collected and analyzed.

The researcher used her experience working with an autistic population ranging from pre-kindergarten through eighth grade as groundwork for her study. The researcher's direct experience working with autistic children largely provoked the proposed research. Personally noticing how beneficial art making can be for an autistic child, the researcher sought to better understand why art was such a powerful and important tool for autistic children. By exploring the deficits and strengths of an autistic child, one becomes better equipped to realize how art fits into an autistic child's world. As an experienced art teacher, the researcher applied her knowledge and training in the field as she constructed a lesson plan to use in the case study. Combining personal teaching experiences with elements of art, principles of design, and related literature enhanced the lesson and made it accessible to both groups of students. The researcher also took the specific ages and stages of development into account as she constructed the lesson.

Theoretical Framework

Before the study could begin characterizing individuals on the autism spectrum, it first addressed the issue of proper terminology. Rebecca Childers (2007) describes the difficulty in defining autism and states that,

> "The terms used vary between clinics, countries and individual clinicians and researchers. There are diagnostic manuals which outline the criteria for autism, Asperger Syndrome, atypical autism and Pervasive Developmental Disorder- Not Otherwise Specified (PDD-NOS) although the criteria are not clear-cut enough to allow unambiguous interpretation" (p. 12).

This research recognized the misconceptions and debates that arise when a child is improperly classified on the autism spectrum. While acknowledging that each child on the autism spectrum has unique characteristics, developmental weaknesses and strengths, some generalities must be presumed in an effort to create context for the research. Julia Kellman (2001) characterizes individuals with an autistic spectrum disorder as

> "part of a long continuum that includes, at one extreme, severely retarded, mute individuals, beset by numerous, compulsive, ticlike behaviors, and at the other, highly articulate, single-minded geniuses with inadequate social skills and a marked inability to take part in the mutual communicative aspects of social existence" (p. 10).

Building from Kellman's (2001) description of typical traits, this research sought to better define the typical characteristics of autistic children's art.

The perspective of art therapists Kathy Evans and Janek Dubowski (2001 suggests that individuals with autism tend to obsess over drawing particular objects. Encouraging them to draw anything else may prove difficult and unsuccessful (p. 40). These obsessions were described by Chilner (2007) as repetitive behaviors that have "special interests or demonstrate particular sensory sensitivities" (p. 69). Likening it to the attributes of individuals with Obsessive Compulsive Disorder (OCD), Chilvers (2007) intimates that individuals with autistic spectrum disorders may struggle with cognitive flexibility and inhibition. She suggests, "Cognitive

flexibility has been linked specifically to rigid thinking and the need for sameness." Thus, this cognitive limitation provides a reasonable explanation for the OCD like qualities in individuals with autism (p. 70). Mindful of these ideas, the research considered how a rigid thought process might affect an autistic child's ability to work creatively.

Investigating the causes to the data, Evans and Dubowski (2001) suggest that autistic children, compared to typically developing children, may have "missed some of the earlier stages of drawing development during which a playful experimentation with a range of art materials triggers a direct emotional response in the child" (p. 46). As a result, children with autism create artwork that is more rigid and void of a strong emotional connection. To examine the validity of this theory, research included interviews and detailed observations of autistic children creating art. The research sought to better understand and potentially validate or devaluate Evans and Dubowski's (2001) theory regarding the role an autistic child's emotion plays in his or her art making.

While the research in the study directly compared typically developing children to autistic children, Nicholas Humphry's (1998) research investigated another potentially pertinent comparison between cave art and drawings made by an autistic girl. Humphry (1998) noted that with cave artists, their "works of art may actually have had distinctly pre-modern minds, have been little given to symbolic thought, have had no great interest in communication and have been essentially self-taught and untrained" (p. 165). The representational nature of these cave drawings is not unlike the drawings of an autistic child. While Humprhy's research infers meaning and rational for these parallels, the proposed research in this study aimed to better understand if Humphry's (1998) findings were valuable and applicable.

Significance of the Study

As rates of autism in America steadily increase (25% in just six years from 2006 to 2012 (Begley, 2012)), so does the demand for educators and professionals in the field to obtain a better understanding of the disability. Educators must find new ways to make their lessons more accessible and valuable to the growing population of autistic students. The proposed research focused on the important role visual art plays in the education and developing communication of autistic individuals. This research benefits not only art educators, but all teachers of autistic children. Regardless of a teacher's specialization, visual art concepts can be utilized in many subjects. The proposed research aimed to enlighten educators on the process and artwork of the autistic population as well as provide these children with important means of self-expression.

Because typical verbal communication is often delayed and/or difficult for autistic children, visual arts provide an outlet for self-expression. In this way, this research is particularly important in empowering an autistic child with a voice. By channeling visual, nonverbal communication, autistic children discover their personal voices and means of self-expression.

The findings of this study also proved useful in acting as an assessment tool, helping teachers better distinguish between the artwork of typically developing children and autistic children. Though by no means diagnostic, knowledge of the distinct qualities found in the artwork of autistic children, compared to typically developing children, may prove to be a useful tool in suggesting further investigations.

Limitations of the Study

Limitations of the study included time constraints, limitations with the participants, practical concerns, and limitations characteristic to autistic individuals.

Time constraints limit the number and variety of art lessons conducted to retrieve data. While the lesson plan conducted by the researcher took experience, artistic standards, and prior knowledge into consideration, numerous lesson plans were truly needed to obtain a wide breadth of data on the topic. Varying elements such as materials, environment, and method of instruction would offer a greater sample of data and ensure the conclusions are not limited. With this in mind, the researcher made an extraordinary effort to provide the students with ample artistic and creative opportunities within the confines of the lesson.

Student participation was accounted for, as the effort put forth could have greatly affected the results. Tying into the time limitations, students did not have numerous opportunities to participate in the study. Therefore, if they were, for any reason, hindered at the time of the data collection (whether it be from lack of sleep, sickness, or an earlier event that has affected their mood), the data collected was analyzed as though it was a true representation of their artistic abilities. Remaining mindful of the potential setbacks, the researcher accounted for the participant's state of being during the study.

There was also concern for the dynamics of the group, affects and influences that associate working in a group environment (as opposed to individual work), and to whether the selected groups of children were representational of their age. As it directly pertains to the autistic group, it was important that the research utilized data from autistic children with similar diagnoses and developmental progress. Autistic children with additional disabilities did not participate in the study. The research included a careful selection process for each group, in an effort to eliminate vast discrepancies between the children. In order for the researcher to remain objective, the cultural perspectives, experiences, and backgrounds of each child were taken into account. Predefined criteria assessed for artistically gifted children and such children did not

participate in the study. At the same time, children with lower than typical artistic abilities and developmentally delayed children did not participate in the study. The research took into consideration the assistance of personal tutors and aides as they pertained to the autistic group of children. Any outside influence that may have affected the results of the study were taken into account.

Availability of materials, environmental constraints, and authorizations from parents were accounted for the practical concerns. Because West Roxbury Public Schools receive restricted funding, materials were limited. The environment remained static throughout the study, as the children were participating in the study during normal school hours and had to remain on the school's campus.

As documented in the theoretical framework, the autistic group of children may have endured personal limitations as a component of their autism spectrum disorder. The extent of these limitations varied from individual to individual. Supplemented by theoretical research, the study sought to better understand and circumvent as many of these limitations as possible, particularly as they pertained to the art making process.

Conclusion

The groundwork for this study was explained and justified by personal motivation and academic importance. The research's motivating questions, methods, and goals were addressed and supplemented with theoretical research. In the following chapter, this theoretical research will be detailed further.

Chapter 2: Literature Review

Research Question

Inspired by the positive way art plays a role in an autistic student's life, the researcher considered how teachers could utilize art in their own classroom to benefit their autistic students. Teachers must first understand exactly how and why visual art is important to an autistic child. Rooting further questions in this knowledge, educators may then ponder how to identify an autistic child's artwork as it compares to a typically developing child's. In the proposed study, the following question was explored: What, if any, are the similarities and/or differences between the process and artworks of typically developing and autistic children attending West Roxbury Public Schools?

Over thirty years ago, Frances Anderson (1978) wrote emphatically about how remarkably valuable arts are to all individuals. He states, "the arts are necessary requisites for what philosophers have called the 'good life'" (p. ix). Today, this statement continues to ring true. For children with autism, art is key to communication and self-expression. The proposed study sought to better understand what makes an autistic child's art unique. Furthermore, the study aimed to ground this knowledge in a better understanding of the ways visual art is a beneficial and elemental component in an autistic child's life. By identifying the positive influence art has on an autistic child, teachers can integrate art into their lessons.

Conceptual Framework

As an art educator at a studio in Acton, MA, the researcher encountered a wide range of students, including those with special needs, who sought to express themselves through the visual arts. Particularly in cases of nonverbal children, art is a spectacular form of self-expression and communication. Inspired by the communicative aspect of art, and provoked by the desire to

teach art to these special populations, the researcher explored the art of autistic children and

searched for meaningful ways to integrate the findings into a classroom setting.

The researcher led an art lesson for both typically developing and autistic children. After

gathering and analyzing the data, the research achieved the goals illustrated in the conceptual

framework of Figure 1. The methods in the conceptual framework were supplemented and

enhanced with related literature.

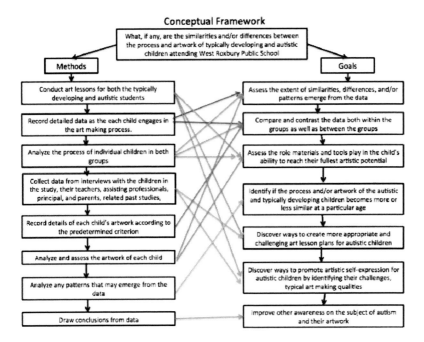

Figure 1. Conceptual Framework

Review of the Literature

The analysis of the reviewed literature rendered a deeper understanding of what it means to be autistic, why art is important to autistic children, how we characterize the art of an autistic child, and ways to use this knowledge in practice.

Understanding autism spectrum disorders. A developmental disorder, autism is described as "a pattern of deficits in social behavior and communication accompanied by restricted and repetitive behaviors or interests as well as an age onset prior to 36 months" (Wetherby, 2000, p. 11). According to the diagnostic criteria in the *Diagnostic and Statistical Manual of Mental Disorders, Fourth Edition,* to be identified with autism spectrum disorder, one must possess aspects of the following:

1. Impairment in social interaction, manifested by impairment in the use of nonverbal behavior, lack of spontaneous sharing, lack of socioemotional reciprocity, and/or failure to develop peer relationships.
2. Impairment in communication, manifested by delay in or lack of development of spoken language and gestures, impairment in the ability to initiate or maintain conversation, repetitive and idiosyncratic use of language, and/or lack of pretend play
3. Restricted repertoire of activities and interests, manifested in preoccupation with restricted patters of interest, inflexible adherence to routines, repetitive movements, and/or preoccupation with parts of objects.

The term *autism spectrum disorder* (ASD) spans the extent to which an individual is affected. This spectrum includes several different, yet sometimes overlapping, disorders. From the more severe end of the spectrum to the less severe end, the disorders are: Autistic Disorder, Asperger's Disorder, Rett's Disorder, Childhood Disintegrative Disorder, Pervasive Developmental Disorders - not otherwise specialized. The term Pervasive Developmental Disorder (PDD) categorizes, and is often used interchangeably with, autism spectrum disorders. Figure 1.2 presents the symptoms along a continuum of severity. Moving from left to right along this

continuum, the symptoms have a "reduced impact on adaptive functioning and the potential for independent functioning increases" (Brock, 2006, p. 5).

SOCIAL INTERACTION			
Socially Unaware	**Limited Social Interaction**	**Tolerates Social Interactions**	**Interested in Social Interactions**
Aloof Indifferent Interaction may be aversive Solitary play	One-way interactions to meet own needs Treats others as tools and interchangeable Prefers solitary play	Two-way interactions Accepts approaches Replies if approached Parallel play	Two-way and spontaneous One-sided Awkward Associative play
COMMUNICATION			
No Language System	**Limited Language System**	**Idiosyncratic Language System**	**Grammatical Language System**
Nonverbal Noncommunicative	Mostly echolalic One-way Used to meet needs	Replies if approached Incorrect pronoun and preposition range Odd constructions	Spontaneous and two way Tends to be one sided Minimal, stereotyped, repetitive behavior
RESTRICTED REPERTOIRE OF BEHAVIORS, ACTIVITIES, AND INTERESTS			
Simple and Body Directed	**Simple and Object Directed**	**Complex Routines, Manipulations and Movements**	**Verbal Abstract Behavior/Interests**
Internal Very restricted range Very marked, stereotyped, repetitive behavior	External Restricted range Marked, stereotyped, repetitive behavior	External Restricted ranged Occasional, repetitive behavior	External Restricted range Minimal, stereotyped, repetitive behavior

Figure 1.2. Symptom Continuum (Brock, 2006, p. 5).

The symptoms are apt to change over time, particularly as a child receives treatment. IQ and language are often most likely to show improvement and move towards the less severe end of the continuum (Brock, 2006).

The treatment of autism can be challenging, as the disorder is thought to have multiple etiologic pathways (Brock, 2006). A variety of treatment strategies have been developed in an

attempt to target, and more aptly address, the broad range of abilities and deficits a child with autism presents. Creative therapies, such as art, have proven helpful in gaining insight into the autism spectrum diagnosis and moving autistic individuals to a higher level of functioning and self-expression (Brooke, 2009).

The benefit of art. To understand the artistic capacity of an autistic child and the extent to which art may be beneficial, one must first realize how visual art fits into an autistic child's world. Autistic children express difficulty in conceptualizing their thoughts and feelings. As a result, they are "limited in their ability to incorporate experiences and adjust behaviors" (Brooke, 2009, p. 23). Art therapy has become a valuable resource for helping autistic children modify their behaviors. Stephanie Brooke (2009) explains that, for children with autism, "art serves as an evolutionary process as they develop from one stage to the next" (p. 24). Brooke (2009) goes on to say,

> "The visual form is useful in integrating nonverbal strategies that are congruent with the AS [autism spectrum] way of thinking. The goal is to build and reinforce new pathways of behavior. The inclusion of art offers the opportunity for genuine, expressive communication beyond the limitations of conventional verbal language. By using both verbal and visual interventions, strategies become reinforced and can be integrated into the individual's new learning, which then leads to behavioral change" (p. 24).

For an autistic child, visual art acts as a conduit for altering behaviors and expressing themselves beyond the limits of verbal communication.

Autistic individuals typically focus on details and struggle to see the big picture. They exhibit difficulty linking one concept or idea to another. Through art making, however, autistic children are able to take their experiences and integrate them into their artwork. In doing so, they create patterns and structures that can lead to bigger picture generalizations and abstract concepts. In this way, art serves as a practice ground for them to visually illustrate relationships between their experiences and ideas (Brooke, 2009).

Art also addresses an autistic child's social and communicative delays. Visual characteristics can be used to teach emotions such as smiles, frowns, happiness, or excitement (Brooke, 2009). Moreover, for many children with autism who do not develop a verbal language, a visual language, such as exchanging picture cards or sign language, becomes an essential form of communication. Nicole Martin (2009) finds that, overall, "receptive language skills (understanding what is said) tend to be stronger than expressive language skills (speaking with clear communicative intent) for people with autism" (p. 19). Thus, art helps alleviate this expressive language deficit by offering an autistic child a means of nonverbal communication.

Art also serves to benefit an autistic child's imagination and abstract thinking. As Martin notes, "imagination, to a greater or less extent, is a deficit area for all children with ASD and is one of the three features of the traditional triad of impairment together with communication and socialization" (Martin, 2009, p. 67). At its most basic level, art requires one to come up with ideas and carry them out. In this way, art is an ideal vehicle for an autistic child to develop and practice steps in the creative process. With teacher guidance, an autistic child can learn how to get in touch with his or her ideas and feelings, brainstorm possible ways to express them, experiment with different materials, problem solve, and explain the final creation. "Art projects such as creating unreal creatures, transformations, or fantastic stories" can be used to practice mental flexibility (Martin, 2009, p. 68). By leading an autistic child through the creative process, they are able to develop their imagination.

Characteristics of autistic children's artwork. Several studies have revealed particular characteristics most commonly found in an autistic child's art. Nicole Martin (2009) depicts these characteristics at length, using examples of autistic children's artwork as it compares to the artwork of a typically developing child. The art of an autistic child oftentimes lacks a

consideration for placement of the subject matter on the page. When working three-dimensionally, "stacking" often occurs. An autistic child places a higher emphasis on the presence, rather than the placement, of objects, and may pile objects on top of one another instead of arranging them in a practical way. This placement issue also becomes evident in drawings and paintings, when little attention is given to the planning process and the autistic child begins a drawing only to realize he or she has run out of room on the paper. As a result, the child will attempt to cram any remaining features of their work into what little space remains, oftentimes compromising the artwork's visual intention and ability to correspond to a viewer. If art is being used as an autistic child's form of self-expression (and potentially a replacement to verbal expression), then stacking serves as an obstacle for these children, as their work becomes a pile of ideas that don't always communicate their intended message.

Martin (2009) notes that autistic children tend to include an unusually high amount of detail in their artwork. This behavior is often described as a hyperfocus. The artwork of many artistic savants displays extraordinary attention to detail. It has been assumed that the need for elaborate detail may be "related to perceptual/sensory issues, preservation and obsessive compulsive behavior, or the need for order and organization, particularly if it involves drawing maps or floor plans" (Martin, 2009, p. 51).

Color sequencing is a term used to describe an autistic child's desire to use color in a rigid order (Martin, 2009). Autistic children desire order and organization, and tend to have rigid ways of thinking (Chilvers, 2007). This rigidity often leads autistic children to "catalog" their art, categorizing subjects within their artwork. For example, an autistic child may become intent on drawing only models of trains or different species of bugs. From the autistic child's perspective, this cataloging is a self-soothing and satisfying way of maintaining order (Martin, 2009).

Obsessive behaviors are prevalent in autistic children. The extent of these behaviors depends on the child's diagnosis and where he or she falls on the autistic spectrum. For most autistic children though, obsessions are demonstrated in their artwork with the persistent use of a particular theme or topic. These preoccupations with particular themes can oftentimes limit their subject variability.

Teaching art to autistic children. It can be difficult for autistic children to develop their own ideas. To assist, Gillian Furniss (2006) suggests that, "children with autism should be given visual references such as photographs of their favorite object." Children with autism often exhibit repetitive behavior and may make multiple, identical drawings. Teachers should not prevent an autistic child from this behavior, as this repetitive activity is "pleasurable and interesting." Instead, autistic children should be encouraged to initiate the art's subject matter and preoccupations (Furniss, 2006, p. 1). In Furniss's opinion, art must be an enjoyable experience for children to continue. Expanding on this notion, art teachers should take aspects of the subject matter the autistic child enjoys and build upon these concepts. Temple Grandin (2012), an autistic woman reflecting on her personal experiences in art, recalls her own fixations. She notes how her teachers encouraged her to build on these fixations, expanding from simply drawing a horse head over and over to drawing the rest of the body, sculpting horses, and creating an environment for the horse. In this way, Temple was able to maintain her interest with art, but break out of her obsession and improve her skills.

Teachers of children with autism must consider the sensory limitations of the child. "Children with autism often experience hyper (too much) or hypo (not enough) stimulation due to their body's poor ability to filter sensory input properly and often require adult help to calm or energize themselves" (Martin, 2009, p. 71). Teachers should encourage children to experiment

with materials and guide them towards sensory integration. It is best to introduce new
(potentially unpleasant) sensory experiences with materials the child is already familiar with and
finds pleasurable. Each exposure to the new sensory experience works to reduce the child's
avoidant behaviors. Furthermore, pairing this new experience with other, more familiarly adored
materials helps to condition the child that the new sensory experience is part of a larger
enjoyable experience (Martin, 2009).

It is important for teachers to understand the best way to connect with a child who has
autism. As Christy Magnusen (2005) explains, "children with autism, many of whom cling to
sensory experiences, are often susceptible to learning new information when their sensory
experiences have a routine element to them" (p. 17). Art is therefore an ideal learning tool for
children with autism, as it provides an extremely sensory experience. Furthermore, when the art
lesson or process follows a routine, the autistic child is apt to flourish.

Conclusion

Tacit. Personal observation has greatly influenced the researcher's belief that visual art
plays an important and integral role in the lives of autistic children. The researcher's personal
experiences, combined with the literature, suggest that there are notable differences between the
artwork of typically developing children and the artwork of autistic children. Further
investigations and data collection provided more insight to these findings.

Theoretical. The reviewed literature aligns with the researcher's tacit understanding and
promotes that art plays a positive role in the lives of autistic children. Theoretical research goes
on to report ways visual arts can be used as a tool for children with autism. Furthermore, it lends
insight into the minds of autistic children and extensively describes the nature of the disorder.

With this information setting the stage, Chapter Three goes on to discuss research methods, the

data collection process, and the data analysis of the student's artwork.

Chapter 3: Methodologies

Design of the Study

To understand how the artwork of typically developing and autistic children varies and/or is similar, the researcher conducted an art lesson with both typically developing and autistic children and compared the process and artworks of the students. The study used the artist Frederich Hundertwasser as inspiration to provoke a visual response from the students. Using oil pastels and watercolor paint, students created their own watercolor resists. By analyzing these visual responses, the researcher was able to better understand how the artworks of typically developing and autistic students were similar and different. The students' process was also observed, noted, and analyzed using Jean Piaget's stages of cognitive development, Viktor Lowenfeld's stages of artistic development, principles of art and elements of design, and the researcher's knowledge based on experience. The researcher photographed the students' work, recorded commentary, and documented student responses to semi-structured interview questions. This research ultimately yielded important data regarding the characteristics of typically and autistic students' art.

Research Methods

The study focused heavily on analyzing the process and resulting artwork of the students after they were taught the same lesson. These findings were supplemented with theoretical knowledge to provide a more comprehensive understanding of the data. A fifty-minute lesson on Frederich Hundertwasser was used in this study and coincided with the student's unit plan. The unit plan utilized in the study aimed to provide students with a better understanding of how artists used shapes and colors to enhance their composition. In keeping with the unit's study of shapes, colors, and lines, the lesson furthered the student's knowledge and provoked personal

responses. After delivering the lesson on Frederich Hundertwasser, data was collected on the student's art making process, personal descriptions of their process, and final artworks. Following the lesson, this data, supplemented by teacher observations, photos, and student conversations, was analyzed. The data was recorded with notes and photographs of the art making process, and resulting artwork. Semi-structured interviews with the students occurred throughout the art making process and lesson. By using a semi-structured format, a relaxed, conversational atmosphere was maintained for the students. This allowed for a more organic, non-disruptive environment for the students as they worked. Simultaneously, structure was preserved, thus making the data easier to analyze and compare. These interviews were logged using a handheld tape recording device that assisted in the researcher's documentation and analyzing of the data.

The researcher enlisted available aides and teachers to assist with recording the data. Their duties included taking photographs that captured the progression of a child's work and recording factual observations (i.e., Child A reached for the blue marker then exchanged it for the red marker). The aides and teachers did not record any assumptions they may have on the event, as it may have skewed the data. The researcher made all inferences from the data. Using autoethnographic research, the study captured each stage of each child's artwork. The photographs were later analyzed. A brief interview was conducted after the lesson with the teachers and aides to gather any additional information they may have noted.

The students involved in the study were either typically developing or autistic children. The children diagnosed with autism did not have any additional disabilities. Though each child was on the autism spectrum, the extent to which autism affected its life varied from individual to

individual. The study was conducted in the art classroom of the typically developing students and the classrooms of autistic students.

Data Collection

Data was collected at the Joyce Kilmer School, a part of West Roxbury's Public School System. The school was comprised of White (61.8%), African American (10.2%), Hispanic (16.1%), Asian (5.9%), Multi-race, Non-Hispanic (5.4%), Native American (.5%) and Native Hawaiian, Pacific Islander (.2%) students (Mass. Dept. of Edu.). Students in the study range in grade levels pre-kindergarten to fourth grade. The art lessons took place in the school's designated art classroom. This art classroom was comprised of three large, group tables that seat approximately six children.

The unit plan that explores how shapes and colors can enhance a painting's composition and provides emphasis is cited in the Appendix as Appendix A1. The lesson plan using Hundertwasser's paintings as inspiration and modeling a superior use of vibrant colors and shapes is cited in Appendix A2. Semi-structured interview questions were asked to students as they worked and after they completed their work. The questions varied, depending on the student's process and artwork, and included:

- Tell me about your work.
- What else will you add to your work?
- Did you plan on mixing those colors?
- How did you make that color?

Questions were asked in the same way to each student, to avoid skewing the data. The researcher also asked spontaneous questions that helped to gain a deeper understanding of the child's rationale and enrich the data. The researcher also kept a journal and document observations of

the student's attitudes, breaks, and peer interactions. The observations documented in the journal were used to supplement the data.

Data Analysis

Following the data collection, the photographs, interview dialogue, and notes were analyzed. The data was sorted by individual students and then grouped by grade level. The data from typically developing and autistic children in the same grade level was compared. The following table was used to compare the usage of principles of art and elements of design found in the children's' work.

Elements of Art and Principles of Design	Typically Developing	Autistic
Lines		
Shape		
Color		
Value		
Form		
Texture		
Space		
Balance		
Contrast		
Emphasis		
Movement		
Pattern		
Rhythm		
Unity		

Table 1. Elements of Art and Principles of Design

Using recorded conversations and notes, the researcher also analyzed the similarities and differences between the process, attitudes, and student's use of tools and materials. The following table was also used:

	Typically Developing	Autistic
Observed process		
Use of tools		
Use of materials		
Attitude		

Table 1.1. Observations

The data inserted into the tables described the range found in each group. These tables with data

inputted are located in Appendix A4. Ranges of characteristics were then discussed in detail

below each chart. Individual works were also discussed in further detail or used as examples. To

achieve a more comprehensive understanding of the data, it was supplemented with Viktor

Lowenfeld's stages of artistic development, Jean Piaget's stages of cognitive development, and

experience. Secondary findings and theoretical knowledge were considered and used to

supplement the study's conclusions. After analyzing the data by grade, the data was investigated

across all grade levels, to ascertain whether there were any trends.

Conclusion

The researcher led the lesson and assisted students as needed. Though the researcher

played an important role in the study, it was important that the students worked as independently

as possible. Throughout the study, the researcher, assisting teachers, and aids remained unbiased.

The data obtained during this study was supplemented with literary resources to ensure

conclusions were obtained through thorough understanding. The results of the study are

discussed in the Chapter Four.

Chapter 4: Results of Study

A fifty-minute lesson on Frederich Hundertwasser was delivered in the same way to autistic and typically developing students in grades kindergarten, first grade and fourth grade. Students used oil pastels and watercolors to create artistic responses. The artworks of the students in each group were analyzed against Gerald Brommer's (2010) Elements of Art and Principles of Design and a second table constructed by the researcher. In this chapter, the significant and secondary findings are described and analyzed.

Significance of Study

The data was triangulated through interviews, photographs, audio recordings, and observations. The findings were compared against a predetermined set of parameters. The findings were compared and contrasted to better understand any similarities and/or differences between the process and artworks of typically developing and autistic children attending West Roxbury Public School. The findings show the ways the artworks are similar and/or different and are enriched through analysis. Developmental and artistic stages were taken into account when analyzing the data to provide a deeper understanding of the results.

The findings of this study closely align with Nicole Martin's (2009) conclusions regarding the artworks of autistic children as they compare to the artworks of typically developing children. The data found in this study enhance Martin's findings by providing a deeper look into the autistic artist. Furthermore, the study's findings more concretely compare the artworks of autistic and typically developing students because they are derived from the same lesson. Unlike Martin's findings that look at autistic children's art from various subject matters and influences, the data from this study is derived from one controlled lesson while the variable (the artwork) was analyzed.

The findings of this study benefit both students and teachers. Armed with an improved understanding of how the artworks of autistic children are similar and/or different from those of typically developing children, teachers can better prepare their lessons and connect to their students. The findings may also aid in the process of identifying autistic children through their artwork. Given the findings of this study, educators can work towards uniting their classrooms and realizing how autistic children are as artistically gifted as their typically developing peers.

Bias and Validity

The researcher remained as unbiased as possible throughout the research. Though the researcher was familiar with most of the students prior to the study, these relationships did not affect the data. The researcher did not take into account any previous artwork the students in the study had created but rather based all data solely off the artwork created from the Hundertwasser lesson. The researcher remained unbiased by evaluating the data from the artwork subjectively and against a predefined list of elements, principles, and subjects. Furthermore, all, with the exception of two, of the students' names were written on the back of their works. Once sorted into groups by grade levels, the artworks were not turned over to reveal the student who created the work.

Students worked at group tables. The potential peer-to-peer influence of this dynamic was considered a validity threat. The typically developing student class sizes averaged 17 students, providing a greater range of artistic abilities. The works most age appropriate were selected to represent their group. The size of the autistic classes averaged around 5 students, greatly decreasing the range of artistic abilities from which to select. All of the autistic student's artwork was included in the study, regardless of their ability. Thus, the study must consider the breadth of work that it was analyzing. Additionally, the data was obtained during one fifty-

minute class. Students were evaluated based off of their performance during that class. Further testing instances would have helped to ensure that the data was consistent, accurate, and representational of the student.

Results and Analysis of Data

A fifty-minute lesson on Frederich Hundertwasser was delivered in the same way to autistic and typically developing students in grades kindergarten, first grade and fourth grade. Students used oil pastels and watercolors to create artistic responses. The artworks of the students in each group were analyzed against Gerald Brommer's (2010) Elements of Art and Principles of Design and criteria constructed by the researcher. This criterion is described in Appendix A3. Data was inputted into tables (located in Appendix A4) and described the range for each group. The significant and secondary findings were discussed.

Kindergarten. In kindergarten, children are in the Preschematic Stage (4 to 7 years) of their artistic development. A relationship between the child's intention and the final product emerges. During this stage, children begin to develop a schema for their work. However, there is little understanding of space and objects are placed haphazardly throughout the picture. Objects that the child perceives to be most important are clearly represented. The use of color is more emotional than logical and often used randomly (Lowenfeld, 1947).

From a cognitive development perspective, children in kindergarten begin to experiment with new ideas and concepts. They oftentimes have difficulty distinguishing between internal and external realities (fantasy and make-believe appear real in a child's mind). Children at this preoperational stage also struggle to consider viewpoints other than their own. They are also developing their fine motor skills and exhibit increased muscle control (Simpson (et al.) 1998, p.41).

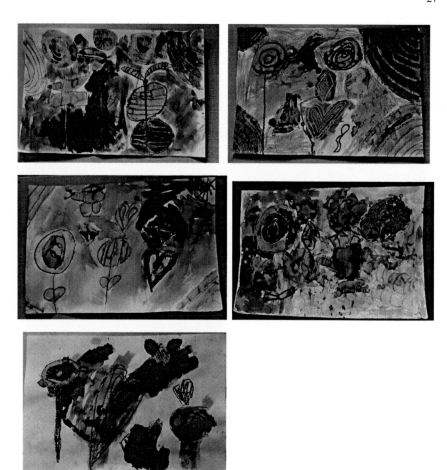

Figure 1.3. Kindergarten typically developing artwork

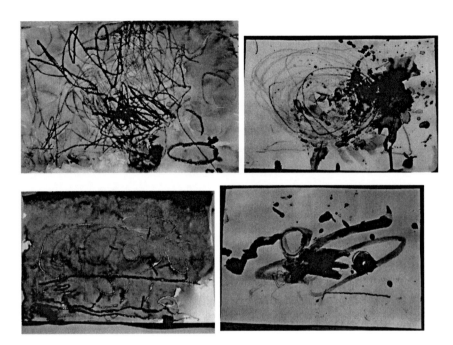

Figure 1.4. Kindergarten autistic artwork

Significant findings. Most of the typically developing students aligned with Lowenfeld's Preschematic Stage. Their artworks accentuated that which was most important and objects were arranged indiscriminately throughout the artwork. When asked what was happening in their artwork, most students described the object that was most important to them. Many students told stories about the objects in their drawings. Their color choices did not necessarily align with those found in nature. Additionally, the dialogue of the typically developing students suggested that they used both the Hundertwasser paintings and personal ideas to create their artwork. All of the interviewed students intentionally mixed the watercolors on their papers (as opposed to the color mixing occurring by accident). Much like the autistic students, most of the typically developing students did not plan how they would use the space, but rather filled the drawing with

more objects after drawing the most important object(s). When asked what they planned to add to their work, half of the students responded that they "didn't know" and the other half responded with their intentions.

Two of the autistic students responded very positively to ongoing references to the Hundertwasser painting and teacher example (see below images).

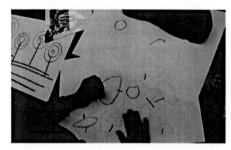 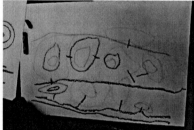

Figure 1.5. Autistic kindergarten students' artwork

These two autistic students moved their eyes back and forth from the teacher example and Hundertwasser painting to their own work. When the watercolor was introduced, several of the students attempted to put the paintbrushes (and paint) into their mouths. All but one of the students touched the end of the paintbrush to feel the watercolor. Three of the four students required some assistance holding their paintbrushes. All of them were able to hold the paintbrush on their own after the teacher's assistance. The typically developing children appeared to have more refined, developmentally appropriate, motor skills than the autistic children.

The autistic students did not vary their lines, colors, or shapes as frequently as the typically developing students. Conversely, the autistic students exhibited a stronger sense of unity and movement in their paintings. This was slightly atypical to their age, as most students operating at a preschematic stage focus more on the objects in their work than the movement or unity between these objects and the paper's space.

Half of the autistic students were still functioning at a scribble stage. However, all of the typically developing students were working at the preschematic stage. This occurrence aligns with Nicole Martin's (2009) findings. She suggests that there is oftentimes an artistic delay in autistic students. Due to this delay, students may function at artistic stages lower than is typical for their age. Martin also goes on to note that autistic children are also likely to skip an artistic stage of development altogether. In the case of this study, the autistic children seemed to straddle the preschematic stage, reverting or progressing to the scribble and schematic stages of artistic development.

Three of the autistic students applied watercolor by first tracing over the oil pastel lines. Two of the students applied watercolor using large brushstrokes that covered the entire paper. One of the students applied watercolors by smashing his paintbrush into his paper. Conversely, the typically developing students most frequently applied watercolor in order of object importance to the shapes on their page. Because most of the autistic students were not drawing at a preschematic level, they did not have an object on their drawing that was more important than another. Therefore, their paint application process differed from the typically developing students'.

First grade. Students in the first grade are emerging from the Preschematic Stage into the Schematic Stage of artistic development. As the children crossover from one stage to the next, overlap can sometimes be seen between the two stages. In the Schematic stage, most children begin to demonstrate most spatial awareness and the separation of base and sky becomes apparent. Children at this stage develop schemas and objects in a drawing have a relationship to what is up and what is down. Unlike the Preschematic Stage, colors are reflected

as they appear in nature. Shapes are more easily definable and exaggeration between figures is often used to express strong feelings and items of importance (Lowenfeld, 1947).

Cognitively, students at this age begin to think more rationally and logically. Their thoughts become more flexible and organized. These children have a limited ability to think abstractly. Contrary to previous stages of development, children at this stage can separate make-believe from fantasy (Simpson (et al.) 1998, p.49).

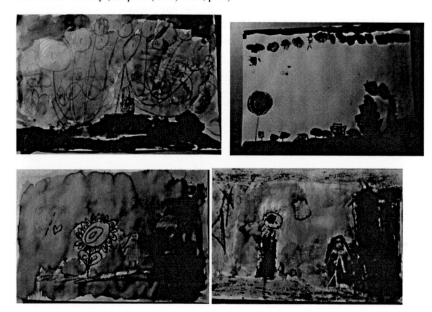

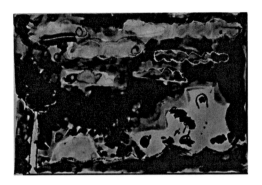

Figure 1.6. First grade typically developing artwork

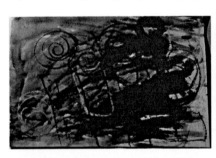
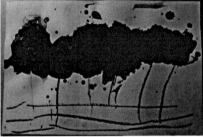

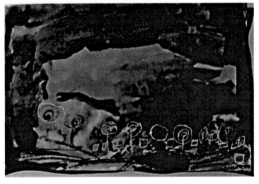

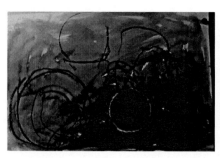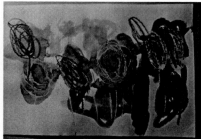

Figure1.7. First grade autistic artwork

Significant findings. The artworks of the typically developing students illustrate steps towards spatial awareness as a clear base and sky emerge. Their color choices, unlike the typically developing kindergarteners, are more aligned with the colors that appear naturally. When speaking about their work, many students explained how Hundertwasser's paintings were used as reference. Furthermore, many students explained that some of the objects in the paintings reminded them of other objects. For example, one student explained that the objects in the Hundertwasser painting look like a bunch of flags, so she was inspired to draw flags in her piece. Another student said that the objects in Hundertwasser's paintings "reminded her of flowers." Her artwork, therefore, incorporated flowers.

Peer conversations and upcoming events were artistic inspiration for many students. A group of girls were excited to attend a birthday party afterschool, so their artworks contained objects like ice cream and cake. Another group of boys were excited about the upcoming holiday (St. Patrick's Day) and used traditional holiday objects (shamrocks, gold) as their inspiration. Some students could not identify the source of their inspiration.

The autistic children did not articulate having a plan prior to beginning their work. In contrast to most of the typically developing students, the autistic students did not use their work as a means to tell a story or describe something of significance in their worlds. When questioned

as to whether the colors that mixed on his painting were intentional, the verbal autistic child responded that it was done intentionally.

The typically developing children tended to have more divergent thinking, considering this an opportunity to explore different themes and subject matter. Fitting with this experimental time of their development, this behavior was very normal for the age group. The autistic children did less divergent thinking and their paintings did not show experimentation with different ideas or concepts. Instead, they created paintings with shapes and compositions that more directly mirrored Hundertwaser's. This finding mirrors the literal thinking that is characteristic to many autistic children.

Unlike the typically developing students, the autistic students did not appear to see new images derived from the Hundertwasser paintings or invent their own. In Nicole Martin's (2009) opinion, labeling these imagination deficits can be complicated. Art, and other creative activities, require some exercise of the imagination. However, an autistic child often searches for the "correct" answer, without understanding that there is no right or wrong when it comes to using one's imagination. What has been referred to as a possible "fourth impairment of autism," the theory of mind refers to an autistic child's inflexibility due to a need to regulate their sensory input (p. 19). This restricted, repetitive, and stereotyped patterns of behaviors do not allow much room for creative imagination. Instead, the process of imagining new ideas is ridden with anxiety and is oftentimes avoided (Martin, 2009).

As in the autistic kindergarten class, peers did not influence many of the autistic first grade students. They worked extremely independently from one another. Peers heavily influenced the typically developing first graders. Though the selected paintings in figure 4.3 do not completely illustrate this point, reoccurring themes and images were prevalent in the class's

work. The social and verbal limitations of the autistic children may have been responsible for this occurrence.

Fourth grade. In fourth grade, some students enter the Dawning Realism Stage of their development. Unlike the previous stages, drawings in this stage appear less spontaneous and more spatially aware. Attempts are made to show depth by varying the sizes of the objects in the drawing. Three-dimensional effects are achieved through shading and the use of color combinations. Children in this stage also become increasingly critical of their artwork and are interested with visual realism (Lowenfeld, 1947).

Students at this age are beginning to develop an understanding of abstract concepts and improve their problem solving skills and awareness. Children at this age are highly influenced by their peers and have a strong desire to be considered part of a group. Rules become a more prevalent part of their lives and children at this age are learning to take responsibility for their actions, while also considering the responses of their peers. A personal set of rules emerges, as do their ideals regarding right and wrong. This influences their art because the child wants to create "good" work, and if it does not compare to the art they intended to produce, it may be considered "bad" work. Some students may therefore begin to lose interest in art if they do not believe they are good (Simpson (et al.) 1998, p. 53).

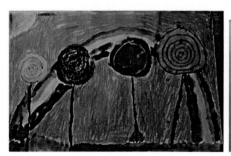 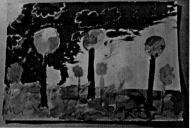

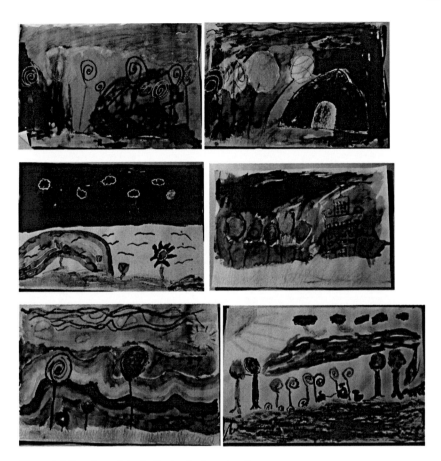

Figure 1.8. Fourth grade typically developing artwork

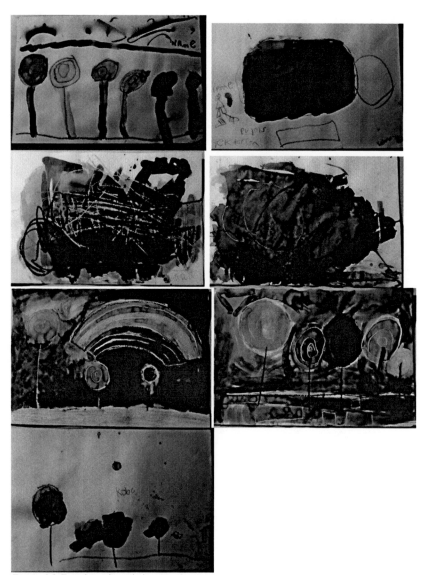

Figure 1.9. Fourth grade autistic artwork

Significant findings. There was a large discrepancy between the artworks of the fourth grade autistic students. These discrepancies were greater than those found in the autistic kindergarten and first grade classes. Their artworks varied greatly in unity, emphasis, control and use of materials, color selection, and space. Of course, individual artistic skill level was taken into account as a possible validity threat. Rainbows and rainbow colors emerged in both the typically developing and autistic students' work.

Because the works of the autistic students vary so greatly, it is difficult to directly compare them to the typically developing fourth graders. For example, the typically developing students had a stronger awareness of space than the lower functioning autistic students. However, compared to the higher functioning autistic students, the typically developing students functioned at the same level. By eliminating the works by autistic fourth graders functioning at a lower artistic level from the discussion, the remaining autistic and typically developing works were very comparable. Perhaps one of the only notable differences between the two groups was the rate that the students worked. Many of the typically developing fourth grade students required the full class period to work. Some did not finish their paintings. The autistic students, however, worked at a much faster pace. Many autistic students were able to produce several artworks. This finding may be related to their attention difficulties. Remaining focused on one task or piece of artwork for an extended period of time is a struggle for an autistic child. The results of this study show the toll of this shorter attention span and the modifications the autistic students made to alleviate their struggle (Brookes, 2009).

Secondary findings. In the autistic group of students, there were two students who were excited to continue making art after they had produced one artwork. One student in particular enjoys art very much. She was quickly able to produce an image of a character she had seen on

TV. Her attention to detail and seemingly photographic memory of the character were notable. Below is the artwork, featuring the character Dora the Explorer.

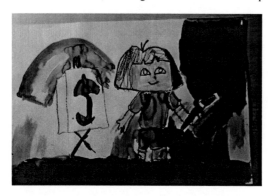

Figure 2. Autistic fourth grade student's artwork

Many autistic children have an extraordinary memory for particular subjects that interest them. In some autistic students, this emerges as a stunning and detailed recollections of movie characters, models of airplanes, or quotes from their favorite shows. For this particular student, her vivid visual memory allowed her to draw the "Dora" (from a television show *Dora the Explorer*) without any visual prompts (Martin, 2009).

Another interesting finding involves an autistic boy who partook in the study twice. First, he was attending art in the fourth grade typically developing class as part of his inclusion program. The second time he was taught the Hundertwasser lesson, he was with his autistic fourth grade class. Below are the two artworks he produced in each class.

Artwork made while present in the typically developing class:

40

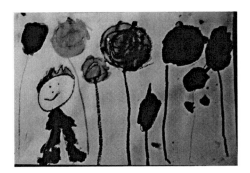

Figure 2.1. Autistic fourth grade student's artwork

Below is the artwork made by the student while he was present in the autistic class. (The

student's name was blurred out of the top of the page. He produced several drawings.)

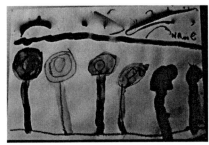

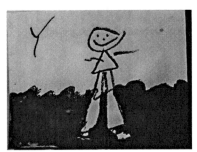

Figure 2.2. Autistic fourth grade student's artwork

One of the most interesting notations between the two Hundertwasser looking paintings is the use of color. During his inclusion class, the student varied the order of the colors he used on the circle shapes. In his autistic class, his colors moved through the color wheel in sequential order. This color sequencing is a frequently noted trait of autistic children's artwork. It is interesting to see that this trait only exhibited itself while the student was amongst his autistic peers.

It was also interesting that this student's first produced the artwork with the red painted center, before creating the painting with the Hundertwasser references. This student was given the same instructions, visuals, and materials in both his fourth grade inclusion and fourth grade autistic class. However, the first painting he produced in the autistic class drastically differs from his painting in the typically developing class. This finding may reflect the student's view of class standards. Perhaps this student is held to a higher standard in his typically developing art class. Or, perhaps he *believes* that he is held to a higher standard and, as a result, rises to meet this assumed expectation. There is also the possibility this student feels more comfortable with his autistic peers, and in this relaxed environment he is more likely to create creative, off-beat artwork. Perhaps the two paintings are nothing more than a reflection of the student's mood that day. Though many arguments could be made, the differences between the paintings are fascinating.

Analysis of kindergarten through fourth grade. As opposed to isolating the data retrieved from each grade level, the data evaluated students whose grades span five years. Moving from kindergarten through fourth grade, interesting similarities and differences were noticed. As Nicole Martin (2009) found, young autistic children frequently show an artistic delay. This atypical development means that the autistic child's artistic development does not

always follow that of a typically developing child and exceptional or even age-appropriate artistic skill is rare. Some autistic children may skip the preschematic stage altogether and instead move from scribbling to drawing recognizable figures without the experimental preschematic stage in between (p. 49). This phenomenon was witnessed in this study, as the autistic kindergarten children's artwork and process did not entirely align with the typically developing child's preschematic stage. In fact, this study showed that some kindergarten children were still functioning at the scribble level, while some were beginning to draw recognizable shapes (as seen in Hundertwasser's work) and incorporating unity and balance to their works. As the autistic children in the study advanced in age, some of their artistic abilities began to more closely align with typically developing peers. By fourth grade, some of the artworks between the autistic and typically developing students were indistinguishable. However, there were also autistic children at this age that still showed an artistic developmental delay.

Nicole Martin (2009) also noted that it could be difficult for autistic children to come up with their own ideas. This was especially evident throughout the grades evaluated in this study. From kindergarten through fourth grade, autistic students consistently and less frequently exhibited creative or new ideas. Instead, the autistic students referred to Hundertwasser's paintings as their sole inspiration, rarely adding ideas from their imagination. It was especially fascinating to see how, even during the free drawing time at the end of class, the drawings of an autistic girl remained literal depictions of a television show of interest. The typically developing students, by comparison, exhibited much more divergent thinking and creative new ideas.

Perhaps due in part to the social deficits and low verbal skills possessed by the autistic students, the effect of peers was not reflected as strongly in the autistic student population as it was in the typically developing student population. In many of the typically developing classes,

43

peer influences were strong. Many of these influences were seen in the students' work. Themes, shapes, colors, and patterns are all examples of peer influence. However, the artwork of the autistic children (in all grade levels) showed a much higher variation of individual work. Working at group tables did not appear to have any effect on the autistic student's ability to create individual artwork. Most of the autistic students did not communicate with their peers during the art making process or look at their peer's work. This observation closely aligns with Stephanie Brooke's (2009) findings that suggest, "as a result of impaired social interactions, those diagnosed with AS [autism spectrum disorder] often experience social isolation" (p.21).

Conclusion

This study shows how the artworks of autistic and typically developing students compare. Though the autistic children frequently exhibited artistic delays from their typically developing peers, there were also many examples of advanced autistic artworks. The artwork of typically developing students could be easily identified through Lowenfield's stages of artistic development. The autistic student's work is identified through a varied list of qualities including an exhibition of literal thinking, lack of preschematic stage artwork, and a very varied artistic level of works from peers the same age. Chapter five will go on to discuss the impact of these findings and rationale of the study.

Chapter 5: Conclusion

Personal Impact of the Study

As an art educator immersed in a school system that has witnessed a rising number of autistic students, this study provided important insight into the characteristics found in autistic children's artwork. By comparing the artworks of the autistic children to those of the their typically developing peers, one can clearly see where the artworks vary and are similar. By honing in on these similarities, art educators can create more inclusive lesson plans for all of their students.

The results of this study extend beyond the art classroom. As many subjects utilize visuals and incorporate art in their lesson, this study arms educators with knowledge and suggestions on how to better adapt their lessons and work through the challenges their autistic students may face. The results of this study act as a predictor for the artistic outcomes of autistic students. By removing the guesswork from the lesson planning process and replacing it with knowledge, the results of this study are extremely important to teachers. Furthermore, from a diagnostic perspective, this research proves extremely beneficial in helping to identify an autistic child through the artwork he or she is producing.

Rationale for the Unit

The unit (referenced in Appendix A) selected for this study was chosen for several reasons. Most importantly was this unit's accessibility to all of the students participating in the study. The abstract subject of trees (or lollipops, depending on one's interpretation) found in Hundertwasser's paintings are a recognizable theme for all of the students, from kindergarten to fourth grade. This familiarity invited students to draw from literal interpretations and recall similar images in their own worlds, (the trees outside their school, etc.) and also created

interesting platforms from which to build new ideas. Due to the abstract nature of these paintings, students were able to expand their thoughts beyond what, on the outset, could have been a very confining theme. Perhaps the best support for using this open-ended inspiration from nature is through a quote from Henry Ward Beecher. He says, "Every artist dips his brush in his own soul, and paints his own nature into his pictures" (St. Peter 2010, p. 68). The students may have used the Hundertwasser paintings as their inspiration at first, but it was their own worlds, experiences, and thoughts that emerged in their paintings. These paintings reflected each student's individual personality.

The elements of art and principles of design played an important role in the decision to craft this unit. To insure consistency, it was important that the study drew comparisons from a table of these elements and principles. It was important that paintings used in this study for inspiration displayed a variety of colors, easily identifiable shapes, lines, balance, and movement. Hundertwasser's paintings not only did this, but also were relatable to children ranging in grade levels from kindergarten through fourth grade.

Recommendations

It would be interesting to continue this research through higher-grade levels. Due to the time limitations of this study, only kindergarten, first, and fourth grade were analyzed. The benefits of continuing this study would include a more comprehensive breadth of understanding. Perhaps there is an age where the gap closes or lengthens between the two groups. What other patterns could be found by including high school, college, and older adults? It would be fascinating to answer these questions.

Upon reflection, the environment of this study is of great interest. As seen in the young fourth grade boy, whose art varied from his inclusion class to his autistic class, it was fascinating

to see the effect his environment had on his work. As he was the only student who participated in the study twice, it would be interesting to see if these results are consistent with other autistic students participating in an immersion program. The environment played an important role on the artwork of the typically developing children as well. Would individual tables have encouraged more individual work? At the same time, it was important to understand the varied results between the peer interactions of typically developing children and autistic children.

It would have benefited the study to employ classroom aides or assisting teachers with video cameras to record the students as they worked. Because the researcher was managing a large class, some student conversations, brushstrokes, and artistic decisions went unseen. Though classroom aides were able to share their observations, it is difficult to compare the inferences of fellow teachers to personal observation. In future studies, it would be recommended that the groups of children are limited to five students. Furthermore, the researcher would suggest repeating this study on numerous groups of five students, to ensure that the mean, as opposed to the range, of artistic abilities is analyzed.

Conclusion

The value of this study extends beyond the art classroom. Educators, classroom aides, parents, and individuals with autism benefit from the insight that was provided by this thesis. Autistic students are not typically developing; to hold them to a standard created for typically developing artists would be unreasonable. This study used these typically developing benchmarks as a point of reference to create new benchmarks. An art's worth is not measured by its ability to match a predefined standard. As famous artist Wassily Kandinsky once said, "there is no must in art because art is free" (p. 32). As a new set of guidelines emerge, the autistic artist

is liberated from the typically developing standards. This study encourages the artwork of autistic children to create its own set of standards.

References

American Psychiatric Association. (2000). *Diagnostic and statistical manual of mental disorders* (4th ed.). Washington, DC: Author.

Anderson, F. (1978). *Art for all the children.* Springfield, IL: Charles C Thomas.

Begley, S. (March, 2012 29). *New high in u.s. autism rates inspires renewed debate.* Retrieved from http://www.reuters.com/article/2012/03/29/us-autism-idUSBRE82S0P320120329References

Brock, S., Jimerson, S., & Hansen, R. (2006). *Identifying, assessing, and treating autism at school.* Sacramento, CA: Springer.

Brommer, J. (2010). *Elements of art and principles of design.* Hong Kong, JP: Crystal Productions Co.

Brooke, S. (2009). *The use of creative therapies with autism spectrum disorders.* Springfield, IL: Charles C Thomas.

Chilvers, R. (2007). *The hidden world of autism, writing and art by children with high-functioning autism.* London, GBR: Jessica Kingsley Publishers.

Evans, K. & Dubowski, J. (2001). *Art therapy with children on the autistic spectrum: Beyond words.* London, GBR: Jessica Kingsley Publishers.

Furniss, G. (2006). Teaching art to children with autism. *SchoolArts,* (May/June), 1-2.

Grandin, T. (2012, August 15). *Temple grandin reveals her advice for educating autistic kids.* Retrieved from http://www.takepart.com/article/2012/08/15/temple-grandin-reveals-advice-educating-autistic-kids

Grandin, T. (1995). *Thinking in Pictures.* New York, NY: Vintage Books.

Humphry, N. (1998). Cave art, autism, and the evolution of the human mind. *Cambridge archaeological journal, 8*(2), 165-191.

Kadinsky, W. (2007). *The art of spiritual harmony.* New York, NY: Cosimo, Inc.

Kellman, J. (2001). *Autism, art, and children: the stories we draw.* Westport, CT: Bergin & Garvey.

Lowenfeld, V. (1947). *Lowenfeld's stages of artistic development.* Retrieved from http://www.d.umn.edu/~jbrutger/Lowenf.html

Magnusen, C. (2005). *Teaching children with autism and related spectrum disorders: an art and a science.* London, GBR: Jessica Kingsley Publishers.

Martin, N. (2009). *Art as an early intervention tool for children with autism.* London, GBR: Jessica Kingsley Publishers.

Maxwell, J.A. (2005). *Qualitative research design: An interactive approach* (second edition). Thousand Oaks, CA: Sage.

Miller, E. (2008). *Girl who spoke with pictures: Autism through art.* London, GBR: Jessica Kingsley Publishers.

Simpson, J. W., Delaney, J. M., Carrroll, K. L., Hamilton, C. M., Kay, S. I., Kerlavage, M. S., & Olson, J. L. (1998). *Creating meaning through art: teacher as a choice maker.* Columbus, OH: Merrill Prentice Hall.

St. Peter, A. (2010). *The greatest quotations of all-time.* United States of America: Xlibris Corporation.

Wetherby, A., & Prizant, B. (2000). *Autism spectrum disorders: A transactional developmental perspective.* (Vol. 9). Baltimore, MD: Paul H. Brookes Publishing Co.

Appendix

Appendix A1

UNIT PLAN

School: West Roxbury Public School
Grade: Kindergarten-4th grade

Title of Unit: Exploring Shapes and Colors

Goals: The goal of this unit is to investigate the elements of art and principles of design. Specifically, this unit aims to provide students with a better understanding of how shapes and colors can enhance a painting's composition and provides emphasis. Furthermore, this unit will explore how artists use shapes and colors in their work.

Students should...
Understand:
- How symmetry can add balance to a artwork (MCAF Standard 2.5)
- Similarities and differences between their work and the artist's work. (MCAF Standard 5.3)

Know:
- How to explain and discuss their artistic decisions. (MCAF Standard 4.1)
- How to identify kinds of lines, shapes, and colors in their artwork. (MCAF Standard 5.1)

Be able to:
- Identify shapes of different sizes and forms in their artwork (MCAF Standard 2.4)
- Create a painting from their imagination, using the artist as inspiration. (MCAF Standard 3.3)

Instructional Concepts
1. Quotes from artists and theorists:
There are infinite shadings of light and shadow and colors... its an extraordinary subtle language. Figuring out how to speak that language is a lifetime job." - Conrad Hall
2. Formal concepts:
- Shapes can repeat
- Colors can vary
- Colors can be combined to create new colors
- Lines can vary in length and width
- Lines can be dark or light
- Colors can be saturated or unsaturated
- Water has an effect on the saturation of a color
- Shapes and lines can overlap

3. **Artistic Behaviors:**
 - Previsualization and planning out the use of lines and colors prior to beginning work
 - Exploring visual concepts such as shapes, colors, and repetition
 - Using artistic vocabulary to describe their work
 - Creating a personal response while recalling the artwork of an artist
 - Promoting visual awareness by introducing the artwork of an artist from another culture

Lessons:

Lesson 1: Students will explore the work of Frederich Hundertwasser. Using his colorful paintings as inspiration, students will design their personal responses. Students will consider composition, how lines and shapes vary, repetition, and the use of watercolors.

Resources and Materials:
- Oil pastels
- Large white paper (18x12")
- Watercolor paints- red, blue, yellow, green, orange, brown, and purple
- Paint brushes – one for each student
- Water cups
- Paper towels
- Frederich Hundertwasser- artist examples

Exemplars:
- A selection of Frederich Hundertwasser paintings:

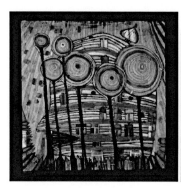 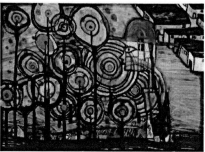

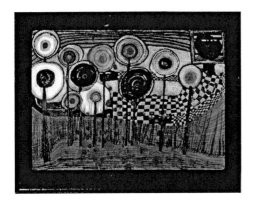

- Teacher created example

Assessment, Evaluation, and Grading:
Did students:
- Learn how artists in other cultures create artwork?
- Learn why composition is important to creating balance, repetition, and emphasis in a painting?
- Use the appropriate artistic vocabulary?
- Understand how colors can mix to create new colors?
- Vary their line width and length?
- Create shapes using lines?
- Use watercolors to create saturated or unsaturated colors?
- Repeat lines, colors, and/or shapes?
- Explore the use of abstraction to create a painting?

Appendix A2

LESSON PLAN

School: West Roxbury Public School
Grade: Kindergarten, 1st Grade, and 4th Grade
Time duration of Lesson: 50 Minutes

Title of Lesson: Exploring Color with Frederich Hundertwasser

Relationship to the Unit: This unit aims for students to gain a comprehensive understanding of elements of art and principles of design. This lesson reiterates knowledge of composition, while adding the challenge of working with oil pastels and watercolors.

Relationship to Life:
 1. **Instructional importance**:
After learning about Frederich Hundertwasser's prominent use of bright colors and whimsical designs, students will see how artists can describe their worlds in a more abstract manner. The influences on Frederich Hundertwasser's artwork will provide students with a backdrop from which to draw a personal artistic response.
 2. **Developmental needs**:
Kindergarten: Students at this stage of development are working to strengthen their ability to pre-visualize and develop their plans for painting before beginning their work. Encouraging the students to thoughtfully decide how they will apply colors to their painting will work to help these students develop artistically. Furthermore, students at this stage of development are developing their visual awareness. Introducing the students to Frederich Hundertwasser provides them with a new springboard for art making.

1st Grade: Students at this stage of development are learning through visual awareness, visual thinking, and the formal elements and qualities of art and design. Students are also working to further develop their understanding of schema and composition. Furthermore, students at this stage of development are developing their cultural awareness. Introducing the students to Frederich Hundertwasser's cultural background provides them with a springboard for art making.

4th Grade: Students at this stage of development are developing their personal voice. Students at this stage are also using artistic strategies such as drawing in the style of a particular artist. By using Frederich Hundertwasser as a springboard, these students can explore their personal responses to his artwork. Additionally, students are eager to work in forms of abstraction, combining observed subjects with the imaginary. Cultivating this urge, Frederich Hundertwasser's works will be used to inspire the students to create their own pieces of abstract artwork.

Problem/Activity Statement:
 Students are challenged to apply an understanding of how oil pastels can be used to create varied lines and shapes and how watercolors can be added over these lines and shapes to create an abstract work of art.

Goals:
Students should...
Understand:
- How artists in other cultures create their work. (MCAF Standard 7.1)
- Ways composition is important in creating balance, repetition, and/or emphasis in a painting. (MCAF 2.6)

Know:
- The appropriate vocabulary related to the methods, materials, and techniques. (MCAF 1.3)
- How to create an expressive artwork that explores abstraction. (MCAF 3.2)

Be able to:
- Experiment with the use of color with watercolors. (MCAF 2.1)
- Explore how lines can vary with oil pastels. (MCAF Standard 2.2)

Objectives:
- Plan the work's composition by using a variety of lines to create shapes.
- Create an abstract artwork inspired by the artist Frederich Hundertwasser.

Instructional Concepts:
1. **Quotes from artists and theorists:**
 "The purest and most thoughtful minds are those which love color the most" – John Ruskin

 "Colors, like features, follow the changes of the emotions." - Pablo Picasso

2. **Formal concepts:**
 - Shapes can repeat
 - Colors can vary
 - Colors can be combined to create new colors
 - Lines can vary in length and width
 - Lines can be dark or light
 - Colors can be saturated or unsaturated
 - Water has an effect on the saturation of a color
 - Shapes and lines can overlap

3. **Artistic behaviors:**
 - Previsualization and planning out the use of lines and colors prior to beginning work
 - Exploring visual concepts such as shapes, colors, and repetition
 - Using artistic vocabulary to describe their work
 - Creating a personal response while recalling the artwork of an artist
 - Promoting visual awareness by introducing the artwork of an artist from another culture

Resources and materials:
 Materials:
- Oil pastels
- Large white paper (18x12")
- Watercolor paints- red, blue, yellow, green, orange, brown, and purple
- Paint brushes – one for each student
- Water cups
- Paper towels
- Frederich Hundertwasser- artist examples

Exemplars:
- A selection of Frederich Hundertwasser paintings:

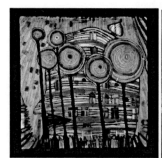 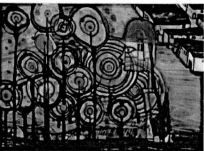

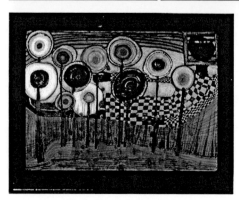

- Teacher created example

Motivation:
The teacher will provide the students with background and cultural knowledge of Frederich Hundertwasser. The teacher will also show the students selected images of Hundertwasser's

paintings. The teacher will draw attention to the use of lines, colors, shapes, and repetition in a two-dimensional form to provoke a personal response from the students.

Questions:

Topic questions:
- How do lines vary?
- What techniques cause these line variations?
- How do colors mix to create new colors?
- What is repetition?
- Why do artists repeat shapes?

Association questions
- Do the shapes in the Hundertwasser images remind you of any shapes you see in your world?
- Have you ever heard of Austria or seen artwork from that country?

Visualization questions
- How will you plan your composition?
- What do you need to create lines?

Transition questions
- Will you use shapes similar to the artist example?
- Will you be drawing many or few shapes on your painting?
- How will you plan to use colors?
- What colors will you use?
- What colors do you plan to mix together on your paper?

Procedures:

Demonstration
- Provide a brief background of Frederich Hundertwasser's influences that lead him to his artistic creations.
- Show images of Frederich Hundertwasser paintings.
- Discuss the way Frederich Hundertwasser used lines to create shapes in his paintings.
- Show students how oil pastels can be used to create lines that are thick or thin.
- Discuss Frederich Hundertwasser's use of watercolors and how colors can be saturated or unsaturated.
- Remind students how to make watercolor paints more or less saturated.
- Show students how to properly add water to the watercolors.
- Reference Hundertwasser's images and point out ways the artist repeats lines, shapes, and colors.
- Producing a teacher made model, show students how to consider the composition of the painting prior to beginning work, how to use oil pastels to make lines and shapes, how to properly use the watercolors to make saturated and unsaturated colors, and how to apply the watercolors with a paintbrush.

Distribution
- The teacher will place oil pastels in the center of each table.
- The teacher will pass out paper.

- Once the oil pastels are no longer being used, the teacher will replace them with water containers, water colors, and paint brushes in the center of the tables.

Work period
- Students work independently at their group tables.
 - o Adaptation for autistic children: Aids and teachers may assist students if needed. Teachers and aids will provide gentle guidance towards the materials, use hand over hand techniques when needed, and assist with maintaining the student's attention on the task.
- Students plan the line, shapes, and colors they will use to make their painting.
 - o Adaptation for kindergarten autistic children: lines and shapes can be added by teachers (many of the students in this class are still at the scribbling stage and may not be able to draw a shape.)
- Students will plan the composition of their design.
- Using oil pastels, students will draw lines and shapes on their paper.
- Students will plan where they will apply the colors
- Using watercolors, students will add color to their drawings.
 - o Adaptation for autistic students: Teachers and aids may have to frequently remind students how to properly use watercolors to achieve the desired saturation. Teachers and aids in the autistic kindergarten class may have to step in to ensure students do not consume the paint and keep it on the paper.

Clean-up
- The teacher will collect the artworks as they are completed and place them on a drying rack.
- The teacher will collect and clean the oil pastels, watercolors, paintbrushes, and water containers. Students who are able will assist with the cleanup process as needed.

Closure
- Students are called upon to discuss some of the different compositions, shapes, lines, and colors that they see in the work of their peers.

Assessment, Evaluation, and Grading:
Did students:
- Learn how artists in other cultures create artwork?
- Learn why composition is important in creating balance, repetition, and emphasis in a painting?
- Use the appropriate artistic vocabulary?
- Understand how colors can mix to create new colors?
- Vary their line width and length?
- Create shapes using lines?
- Use watercolors to create saturated or unsaturated colors?
- Repeat lines, colors, and/or shapes?
- Explore the use of abstraction to create a painting?

Appendix A3

Elements of art and principles of design as they apply to the unit and lesson

The elements of art and principles of design, described by Gerald Brommer (2010), are

listed in the table below. It is important to ensure a common understanding of each of these

elements and principles as they apply to the provided lesson. **Lines** include marks made by the

oil pastels and paintbrushes. These lines can be thick, thin, curved, angular, loopy, broken, light,

and dark. **Shape** is an area that is contained within an implied line, or is seen because of color or

value changes. Shapes have two dimensions, length and width, and can be geometric or organic.

Colors are characterized by intensity, value, and hue. **Value** refers to dark or light. **Form**

describes objects that are three-dimensional, having length, width, and height. **Texture** refers to

the surface quality, both simulated and actual, of the artwork. In the case of the Hundertwasser

lesson, texture will be limited to the varied use of oil pastels and watercolors. These pastels and

watercolors can create textures if layered. Though not a prominent aspect of the artworks, texture

will be considered in this way. **Space** is a three-dimensional volume that can be empty or filled

with objects. Space includes the artist's use of perspective and depth.

Balance is the first of the principles of design. It is the comfortable or pleasing

arrangement of things in art. It refers to the arrangement of elements on either side of the

centerline. Shapes, colors, and values can be arranged to create a sense of balance. **Contrast**

refers to the differences in values, colors, or other art elements in an artwork. **Emphasis** gives an

artwork a focal area. It makes what is most important in the artwork stand out. An artwork that

has **movement** takes viewers on a trip through the work by means of lines, edges, shapes, and

colors. Often, this movement leads the viewer to a focal area. **Pattern** uses the elements of art in

planned or random repetitions to enhance surfaces of the artwork. **Rhythm** is the repetition of

shapes, lines, and forms. **Unity** makes the artwork feel complete. When unity is achieved, all of the elements in an artwork are in harmony.

Appendix A4

Kindergarten:

Elements of Art and Principles of Design	Typically Developing	Autistic
Lines	Vary- curved, straight, dark, light	Less variation- lines are curved, straight, similar weight
Shape	A variety of shapes are used- circles, squares, hearts, triangles, etc.	Shapes are limited and are mostly circles
Color	Varied. Numerous colors are used. Colors range in hue, value, and intensity	Limited. Colors do not vary in intensity. Mon
Value	Ranges from light to dark with watercolors	Slight range, mostly dark with medium values
Form	No suggestion of 3D forms	No suggestion of 3D forms
Texture	Oil pastels overlap and create textures. Watercolors overlap and create textures	Watercolors overlap and create textures
Space	Some to most area of the artwork is utilized. Objects occur on	Some to most of the area is utilized. Objects are mostly centralized on the paper
Balance	Most to all of the artworks exhibited some balance.	Only one artwork exhibited balance
Contrast	Contrast was seen in all artworks with light and dark values and varying colors	Contrast was seen in most artworks- varying light and dark values, and contrasting colors
Emphasis	Objects were accentuated with larger sizes and more detail. Colors were sometimes used as emphasis	Drawn objects were the same size. Varying colors sometimes added emphasis
Movement	Despite the objects in the drawing extending to all edges of the paper, it was often difficult to decipher a line of movement. The viewer's eye does not always follow the same movement line. Drawings were mostly static.	Drawings had movement. Drawn oil pastel lines and watercolor lines lead the eye through the drawing.
Pattern	Patterns were used in each drawing. Most patterns were repeating lines.	No recognizable patterns were identified.
Rhythm	Some artworks used patterns to create small areas rhythm, but rhythm did not frequently unite	One artwork uses lines throughout the work to create rhythm.

	the objects in the artwork	
Unity	No strong sense of unity in artworks. Few have a slightly harmonic feel.	Stronger sense of unity.

	Typically Developing	Autistic
Observed process	- Expressed planning tactics - Colors were selected based on emotion - Students seemed oftentimes influenced by their peers - Most students were influenced when shown and reminded of visual images - Many students used their drawings to convey stories - Many students made connections between the images in Hundertwasser's paintings and objects in their world	- Did not express planning tactics prior to beginning work (the nonverbal children did not sign with their artistic intentions, and the verbal children did not express plans) - When watercolor was introduced, oil pastel marks were often traced first - Students did not appear influenced by peers. - Most students were influenced when shown and reminded of visual images
Use of tools	Tools were held conventionally. Motor skills appeared concrete.	Brushes were held by far end of handle (away from brush)
Use of materials	- Students used materials liberally, enjoyed mixing and applying colors - Many students requested specific colors	- Students used materials quickly. - Some students splashed watercolors and applied oil pastels with large motions.
Attitude	- Students were very excited to make art "just for fun"	- Some students struggled to focus on the project - Some students were excited to make art - Some students required the teacher's/aid's encouragement to remain focused

First Grade:

Elements of Art and Principles of Design	Typically Developing	Autistic
Lines	Lines were varied- curved and straight Most students used dark lines, some used light	Lines were varied- curved and straight Most students used dark lines, some used light
Shape	Most students used a variety of shapes- circles, squares, hearts, ovals, triangles, and organic shapes	Most students used a variety of shapes- circles and squares
Color	Most students used a variety of colors. Colors often resembled colors found in nature. All students mixed watercolors to create new colors.	Most students used a variety of colors. All students mixed watercolors to create new colors.
Value	Most students exhibited variations in color value including dark, middle, and light values.	Every students exhibited variations in color value including dark, middle, and light values.
Form	3D forms were sometimes implied, though most objects remained 2D	No 3D forms were suggested
Texture	Texture was limited. Some textures were implied when watercolors overlapped	Oil pastels overlap and create textures. Watercolors overlap and create textures.
Space	Space was implied in most artworks. These artworks used overlapping and size variations to imply depth	Space was implied in few artworks. These artworks used overlapping and size variations to imply depth
Balance	Most artworks were symmetrically balanced	Most artworks were symmetrically balanced
Contrast	The contrast in the artworks varied from low to high. Much of the contrast was accomplished with the size of the objects. Some of the artworks exhibited contrasts in temperature and value.	The contrast in the artworks varied from low to high. Much of the contrast was accomplished through variations in temperature and value. Some of the artworks exhibited size of the objects.
Emphasis	Most of the artworks exhibited emphasis through size or color.	Few of the artworks exhibited emphasis through color.
Movement	All of the artworks exhibited movement	All of the artworks exhibited movement
Pattern	Few of the artworks used patterns	Non of the artworks used patterns

Rhythm	Many of the artworks possessed irregular rhythms and one possessed repetitions	Many of the artworks possessed repetitive and/or irregular rhythms
Unity	Most artworks possessed unity through colors, shapes, and stroke marks	All artworks possessed unity through colors, shapes, and stroke marks. Artworks displayed more unity than those in the typically developing group

	Typically Developing	Autistic
Observed process	- Most students referred to the Hundertwasser images, then combined these images with their own ideas to create their artworks. Some students did not use the paintings as inspiration. - Most students planned and considered how they wanted their art pieces to look prior to beginning work. - Many students drew objects that interested them to tell a story through their artwork - Many students were influenced by their peers	- Nearly all of the students referred to the Hundertwasser images to create their own artworks. - Some students mixed watercolors intentionally - Some students began applying watercolor by tracing over the drawn objects. Other students applied watercolor in large brushstrokes, covering the paper. - Some students layered watercolors until their papers were saturated.
Use of tools	Tools were held conventionally. Motor skills appeared concrete.	Most tools were held conventionally. Some students held their paintbrushes at the far end. Most motor skills appeared concrete.
Use of materials	- Students were eager to use watercolors quickly. Many applied watercolors in large strokes. Some students applied colors more slowly, to small, detailed space of their work. - Some students used a variety of oil pastel	- Students were eager to use watercolors quickly. Many applied watercolors in large strokes. Many applied watercolors over their drawn objects. Many students layered their watercolors to make a very saturated color or a new color.

		All students used a variety of oil pastel colors. Most students used large strokes to describe their objects. Few students used were attentive to drawing smaller details.
	colors. Some students did not vary their oil pastel color use as much - Most students were attentive to drawing small details in the drawing with oil pastels. Few students used larger strokes to draw objects.	- All students used a variety of oil pastel colors. - Most students used large strokes to describe their objects. Few students used were attentive to drawing smaller details.
Attitude	- Students were enthusiastic - Students enjoyed the freedom of drawing what they wanted - Students were excited to share the story behind their artwork.	- Students were enthusiastic - Students enjoyed mixing colors

Fourth Grade:

Elements of Art and Principles of Design	Typically Developing	Autistic
Lines	Lines varied in weight and shape	Lines varied in shape. Did not vary as much in weight
Shape	Students used a large variety of shapes	Students used a large variety of shapes
Color	- Colors were extremely vibrant. While some colors mixed, most colors remained bright and saturated. - Students used a variety of colors (most students used almost all of the available watercolor colors)	- Many colors were mixed to create new colors. Some of these colors became dark and muddy. - Most students used a variety of colors (most used all of the available watercolor colors)
Value	All students exhibited variations in color value including dark, middle, and light values.	Some students exhibited variations in color value including dark, middle, and light values.
Form	No 3D forms were represented	No 3D forms were represented
Texture	Oil pastels overlap and create textures. Watercolors overlap	Watercolors overlap and create textures.

	and create textures.	
Space	- Had a strong awareness of space. One child, "Somebody pass me the green, I need to make grass. I don't want my tree floating in mid-air!" - Space was inferred by creating horizon lines, overlapping shapes and the size of shapes.	- Space was inferred by creating a horizon lines and overlapping shapes and the size of shapes -
Balance	Most artworks showed symmetrical balance. Some students used asymmetrical balance.	Most artworks were symmetrically balanced.
Contrast	Some artworks used high, medium, and low contrast. Few artworks used only low and medium contrast levels	All artwork had high, medium, and low contrast (Many had high contrast due to the white space remaining on the paper).
Emphasis	Some artworks used color and size to show emphasis.	Some artworks used color and size to show emphasis.
Movement	All artworks had movement. Most movement was linear.	Most artworks had movement.
Pattern	Some artworks used patterns to add detail to their drawings.	Few artworks used patterns.
Rhythm	Many artworks had rhythm.	Some artworks had rhythm.
Unity	Most artworks had unity. Some lacked unity due to time constraints	Many artworks appeared to have unity.

	Typically Developing	Autistic
Observed process	- Many students were eager to share the stories behind their artworks. - Some students were influenced by their peers. - Many drawings were done carefully, with high attention to details. (Some students did not even get to the watercolor step as they were engrossed in their drawings.)	- Some students applied oil pastel marks and watercolor liberally and without apparent planning. Other students worked more slowly, with more controlled movements and showed signs of pre work planning - Some students did not appear to plan their work. Large strokes were used to draw and paint objects.

	- Students periodically changed the colors of their oil pastels and watercolors - Nearly all students painted the objects before painting their backgrounds.	- Nearly all students referred back to the Hundertwasser paintings several times during their art making process. - Most students were excited to spend time on their artwork. Other students were not as interested in the duration of time that the artwork required
Use of tools	Students used the tools appropriately and conventionally (No one used the oil pastel on its side or used their paintbrush for anything other than brushstrokes.)	Students with lower functioning motor skills held the end of the handle of their paintbrush. However, most students showed concrete motor skills.
Use of materials	- Many students used their oil pastels slowly to create details. Most students applied their watercolors more quickly	- With the exception of a few, most oil pastels were used slowly for drawing - With the exception of a few, most watercolors were applied slowly and carefully.
Attitude	Students were happy to participate	Most students were happy to participate. Some students struggled to remain focused. Some students were excited to continue drawing after they had finished their work.